I WROTE THIS FOR YOU

pleasefindthis

IAIN S. THOMAS

central
avenue
publishing

2016

Published by Central Avenue Publishing, an imprint of Central Avenue Marketing Ltd.

www.centralavenuepublishing.com

Published in Canada
Printed in United States of America

1. POETRY / General 2. POETRY / Themes & Subjects

Dear You,

You are holding in your hands what was promised to you years ago. I'm sorry it took so long. But life, as is so often the case, is life and we forget about the promises we've made.

You, however, are harder to forget.

I know the world is crazy. I know love is not always the way it's meant to be. I know sometimes, things hurt. But I also know that we'll get through this. That our hearts will arrive on the other side, in one piece. That everything is beautiful, if we give it the chance to be.

I've tried to write down what I saw and what you told me and I sincerely don't think I missed anything. Let me know if I have.

I love you. I miss you.

Me

SUN,

MOON,

STARS,

RAIN.

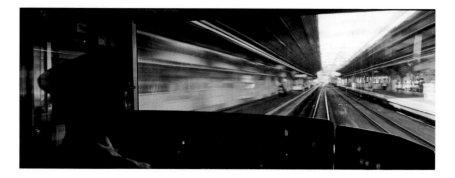

THE DEDICATION LIST

To the small.

To the star counters.

To the cloud watchers.

To the inspired.

To the birds.

To everyone who's ever cried.

To everyone who's ever tried.

To those who pull themselves up off the floor.

To those who can still find love in their hearts, even after everything.

To those who paint the world each day with the colours of their feelings.

To those who hope.

To you.*

*Thank you.

SUN,

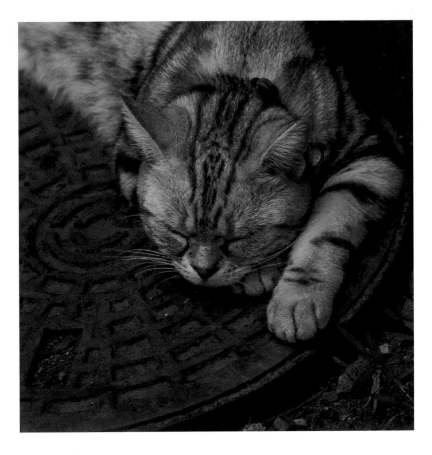

THE FUR

Be soft. Do not let the world make you hard. Do not let the pain make you hate. Do not let the bitterness steal your sweetness. Take pride that even though the rest of the world may disagree, you still believe it to be a beautiful place.

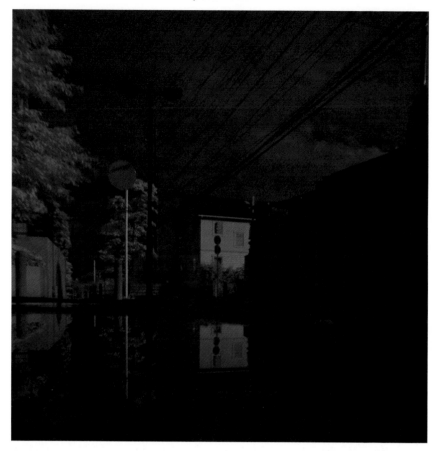

THE LAYERS UNSEEN

There is magic even here, in gridlock, in loneliness, in too much work, in late nights gone on too long, in shopping trolleys with broken wheels, in boredom, in tax returns, the same magic that made a man write about a princess that slept until she was kissed, long golden hair draped over a balcony and fingers pricked with needles. There is magic even here, in potholes along back-country roads, in not having the right change (you pat your pockets), arriving late and missing the last train home, the same magic that caused a woman in France to think that God spoke to her, that made another sit down at the front of a bus and refuse to move, that lead a man to think that maybe the world wasn't flat and the moon could be walked upon by human feet. There is magic. Even here. In office cubicles.

THE FIRST SIGN IS TAKING STRANGE PICTURES

I have pretended to go mad in order to tell you the things I need to. I call it art. Because art is the word we give to our feelings made public. And art doesn't worry anyone.

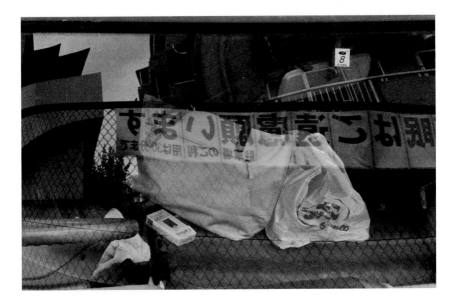

THE BIBLIOGRAPHY OF STRINGS

And you taught me what
this feels like.
And then how it feels to
lose it.
And you showed me
who I wanted.
And then who I wasn't.
And you ticked every
box.
And then drew a line.
And you weren't mine to
begin with.
And then not to end
with.
And you looked like
everything I wanted.
And then became
something I hated.
And you get thought of
every day.
And then not in a good
way.
And you let me leave.
And then wish I'd
stayed.
And you almost killed
me.
But I didn't die.

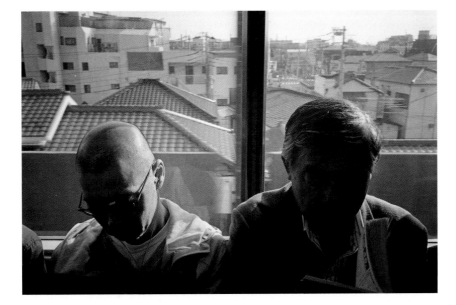

THE CORNERS OF
YOUR MOUTH

And you asked why people always expected you to smile in photographs. And I told you it was because they hoped that in the future, there would be something to smile about.

THE SHAPE OF IT

They want me. I want you. And you want someone else.
But none of us want to turn around.

THE POINT OF CONTACT

And then my soul saw you and it kind of went

"Oh there you are. I've been looking for you."

THE TIME IT TAKES TO FALL

So if all we have is that glance in the window. If all we have is till this train stops. If all we have is till the sun comes up, till your lift picks you up. And if all we have is till the day I die.
I'm ok with what we have.

THE SEAT NEXT TO YOU

When I sit near you, my hands suddenly become alien things and I don't know where to put them or what they usually do, like this is the first time I've ever had hands and maybe they go in my pockets and maybe they don't.

THE SHIPWRECK IN MY HEAD

Everything you do, you pay for. So if you're going to kiss me, you'd best be prepared to bleed.

THE PATTERN IS A SYSTEM IS A MAZE

Of course it's complicated. If it wasn't, I probably wouldn't be interested in you.

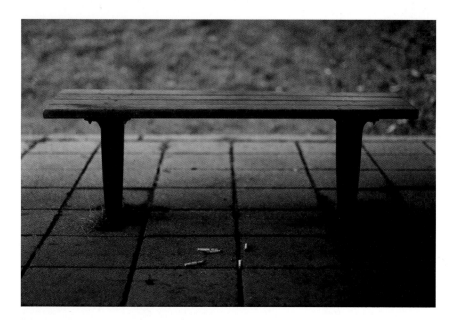

THE MISSED APPOINTMENT

So yes, we could kiss. I could kiss you and you could kiss me. There's no science, plane ticket or clock stopping us. But if we kiss, it will end the world. And I've ended the world before. No one survived.

Least of all me.

THE NEW COLOUR

And their shape and their hair and their eyes and their smell and their voice. That suddenly, these things can exist and you're not quite sure how they existed without you knowing about them before.

THE MOTHS DON'T DIE FOR NOTHING

I'm sure people just kiss each other. I'm sure that sometimes you're talking and somehow two people move closer and closer to each other and then, they just kiss. I'm sure it happens all the time. But I'm also sure that a kiss is never just a kiss.

THE CLEARLY LABELED

I think you'll find you're mistaken. My name is clearly written across the front and I recognise the scratch down the side (that happened in high school). This is my heart. You can't just come here, and take it.

THE DRIVE BEFORE DAWN

I read what you leave in public spaces. The songs you reference. The quotes you quote. I know it's about me. I can feel you thinking of me. I want to tell you that I know and admit that I feel the same. But I can't. Not yet.

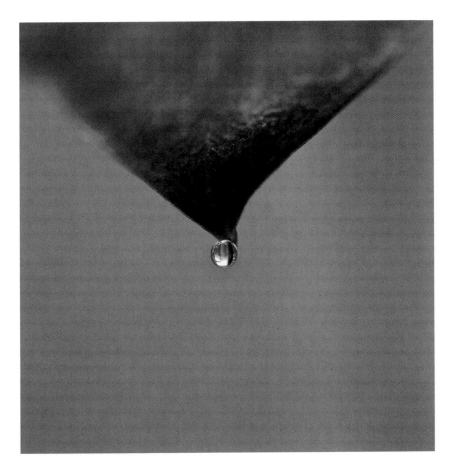

THE WET HAIR AND EYES

You are a drop of perfect in an imperfect world. And all I need, is a taste.

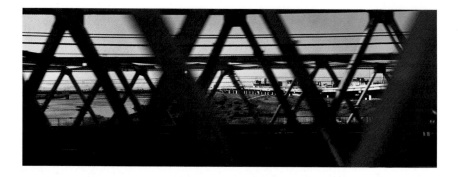

THE SHAPE FALLS AT YOUR FEET

Maybe it's because you're one of those people that believes that sometimes, the most reckless thing you can do with your heart, is not being reckless with it.

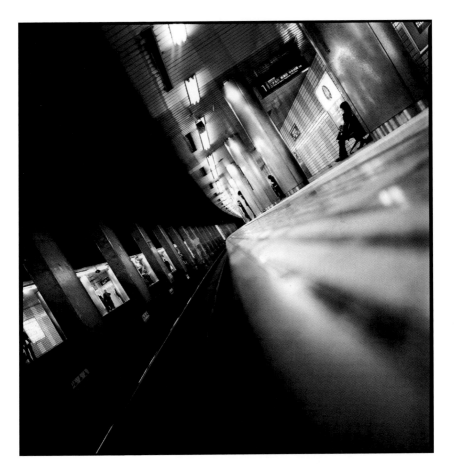

THE EXCUSE FOR YOUR COMPANY

I was wondering if you had a second. To talk about anything at all.

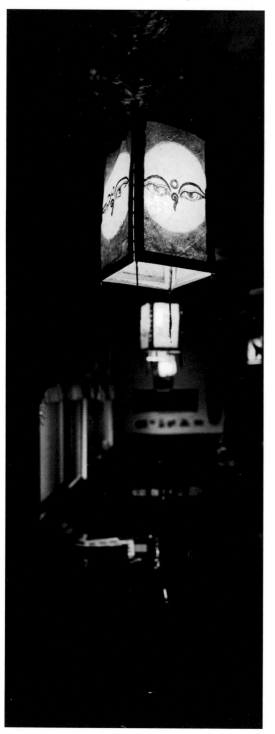

THE LANTERN IN THE LIFEBOAT

I am nervous. I'm afraid. But I will stand here in the white hot heat of you. I will play Russian roulette with your playlists. I will tell jokes I'm not sure you'll find funny. I will hold on until there is no more reason to. And in the end, I will break the stars and resurrect the sun.

THE PAINT HIDES THE BRICK

You took all my words when all I wanted to do was say them.

THE WAY GLASS BREAKS

This is the song I only sing when you're sleeping. These are the words I say when you can't hear me. This is the way I look when you can't see me. And you will never know.

THE TRUTH IS BORN IN STRANGE PLACES

Joan of Arc came back as a little girl in Japan, and her father told her to stop listening to her imaginary friends.

Elvis was born again in a small village in Sudan, he died hungry, age 9, never knowing what a guitar was.

Michelangelo was drafted into the military at age 18 in Korea, he painted his face black with shoe polish and learned to kill.

Jackson Pollock got told to stop making a mess, somewhere in Russia.

Hemingway, to this day, writes DVD instruction manuals somewhere in China. He's an old man on a factory line. You wouldn't recognise him.

Gandhi was born to a wealthy stockbroker in New York. He never forgave the world after his father threw himself from his office window, on the 21st floor.

And everyone, somewhere, is someone, if we only give them a chance.

THE IMPORTANT THINGS HUMANS DO

Go to work. Eat. Dream. Try to sleep. Think of you.

Count the stars. Wake up. Think of you.

Be here. Listen to what they're saying. Think of you.

Cook. Read. Watch TV. Think of you.

Pay attention. I'm thinking of you.

MOON,

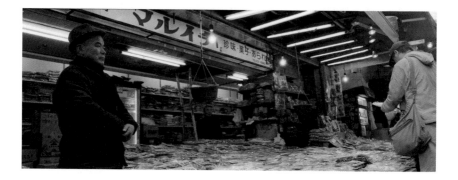

THE CHILDREN OF TIME

January has issues with her mother, February is always talking about things he wants to do while March does them, April eats sweets and May pays for them, June is the oldest but not the wisest and July always has an opinion on everything. August never stops trying do the right thing, even if he doesn't always know what that is. September once saw something so sad, she never stopped crying. October holds the lift for anyone, vice-presidents and street-sweepers alike (for his memory, not for theirs) and November makes fun of him for this. December is tired but always hopeful. He has never once stopped believing.

Monday's obviously a bastard, quite literally as Dad can't remember what or who he was doing. Tuesday's temperamental but ok as long as you stay on her good side. Wednesday doesn't say much and Thursday sometimes hums just to break the silence. They're in love. Friday's always wasted and she and Saturday hold each other tightly until their delirium fades.

But Sunday, Sunday knows she's the end. But she closes her eyes, and she pretends with all the strength in her tiny heart that really, she's the dawn.

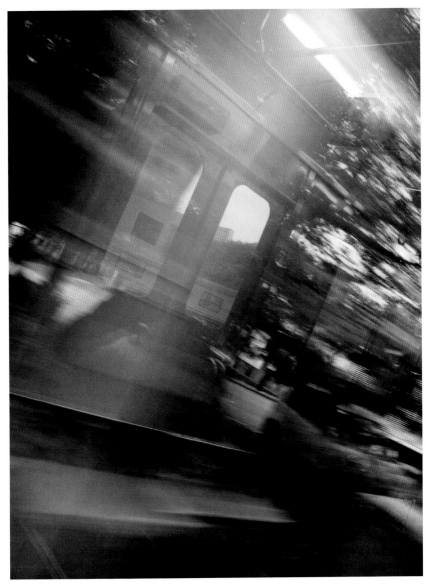

THE GHOST TRAIN

And if you can't say yes, answer anyway. Because I'd rather live with
the answer than die with the question.

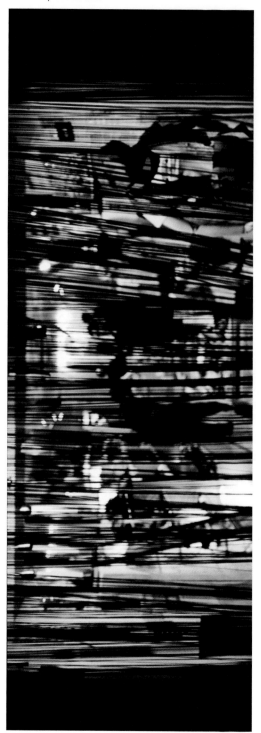

THE DAY TOMORROW CAME

I know you're busy doing all the things you always planned to do but remember, today is also the day that you kiss me.

THE TRAIN OF LIES

I say that I won't touch you.

But my fingers are liars.

I tell you how I won't hold you.

But my arms are going to hell.

I promise I won't kiss you.

But my lips break it.

I let you know that I won't love you.

But my heart has no conscience.

And no part of me will apologise.

THE FRAGILE ARC

It may have just been a moment to you,
but it changed every single one that followed for me.

THE CORNER OF ME AND YOU

I don't know if you felt that or not.

But it felt like two people kissing after hours of thinking about it.

It felt like two people talking after nights of silence.

It felt like two people touching after weeks of being numb.

It felt like two people facing each other after months of looking away.

It felt like two people in love after years of being alone.

And it felt like two people meeting each other, after an entire lifetime of not meeting each other.

THE BOOKS NEVER WRITTEN

Dragons, angels, gnomes, creatures beneath the earth that make words with hammers, a shooting star that shoots back, rain falling from the ground to the sky, bars that refuse to serve dwarfs or wanderers, a fountain that makes you young (and lonely) while those around you grow old, saplings that know everything, a sea made of tears from every lover who never loved, a silver boat with a sail made of pages from all the books that were never written.

All my dreams are beautiful. But none as beautiful as you. You are the reason I return here each morning.

THE TO NOT DO LIST

There are a million important things to do. But none as important as lying here next to you.

THE RULES OF ENGAGEMENT

All persons entering a heart do so at their own risk. Management can and will be held responsible for any loss, love, theft, ambition or personal injury. Please take care of your belongings. Please take care of the way you look at me. No roller skating, kissing, smoking, fingers through hair, 3 am phone calls, stained letters, littering, unfeeling feelings, a smell left on a pillow, doors slammed, lyrics whispered, or loitering. Thank you.

THE SPEED OF FEELING

Now you've gone too fast. Now, you've made me leave me behind.

THE HEART BEATS PER MINUTE

You are the best parts of all the songs I love.

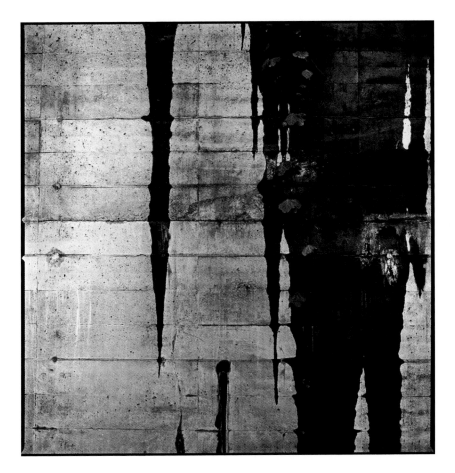

THE NEEDLE AND INK

Look at you, like a new tattoo. Because I might not always have you but I'll have the feeling of you for the rest of my life.

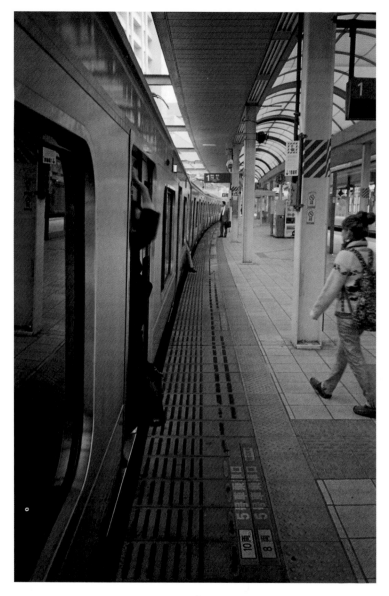

THE HEART RIDES ON

I love you. I love your eyes. I love your smell. I love your hair. I love your laugh. I love your skin. I love everything inside you. And I'll try to make all the parts that I find, happy.

Because you make me happy. So much.

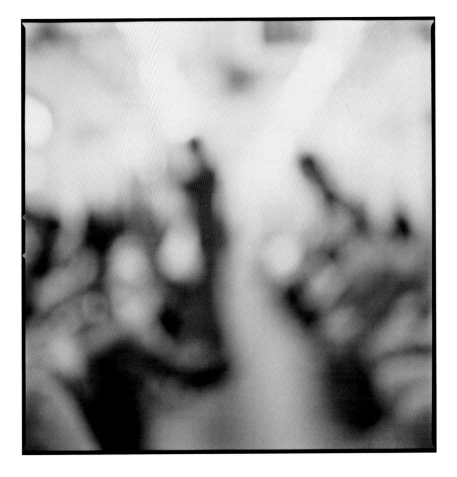

THE LOVERS
BLEED INTO
EACH OTHER

And as we touch, I can
never tell if you are
touching me or I am
touching you.

THE THINGS THAT ARE LEFT

The world made me cold. You made me water.

One day we'll be clouds.

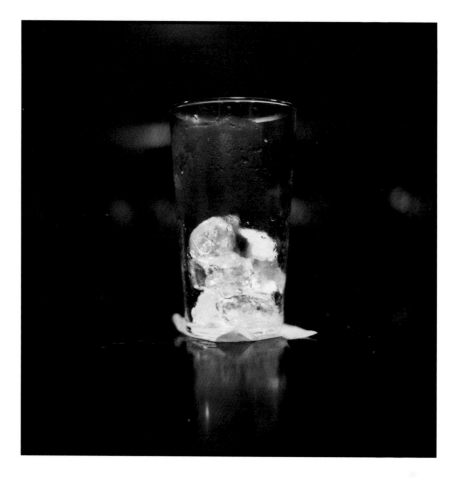

THE CIRCUS IS CHEAPER WHEN IT RAINS

I've taken the same ride too many times.

I could fall asleep in the loop.

I know the clowns wipe the fake, makeup smiles off their faces once the show is done.

I know the lions sleep in cages at night.

I know the tightrope walkers have blisters on their feet.

I know the ringmaster doesn't believe in what he yells to the crowd anymore.

I know the strongman, isn't as strong as he once was.

I know the candy floss has always been, just sugar and air.

You are the only reason I come back here every night.

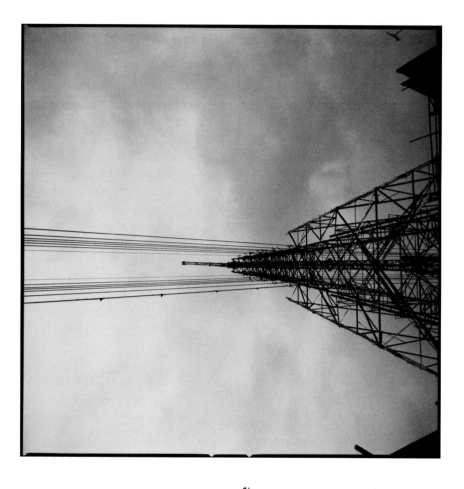

THE SONG ACROSS
WIRES

I'm a picture without a frame.
A poem without a rhyme.
A car with three wheels.
A sun without fire.
I am a gun without bullets.
I am the truth without someone
to hear it.
I am a feeling without someone
to feel it.
This is who I am.
A mess without you.
Something beautiful with you.

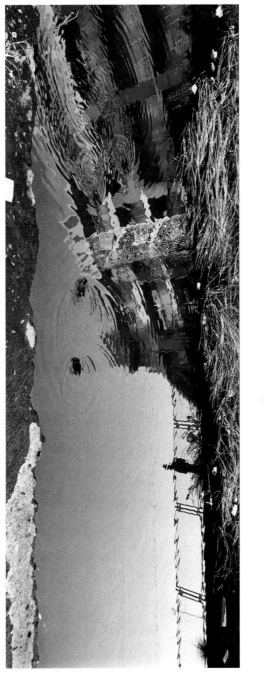

THE FURY OF WATER

You can try and hold me back. Build your damn walls, pack sandbags along the edges and yell at the clouds and the rain and the sky to stop.

But I will not relent. I will reach you. Because I am the sea. And I will continue to love you no matter what.

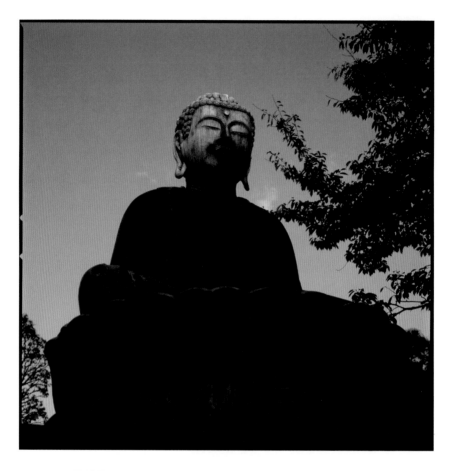

THE PLACE WHERE NOTHING HURTS

There is no music, just the sound of the wind and the leaves it touches. But hopefully that'll be music enough, for you.

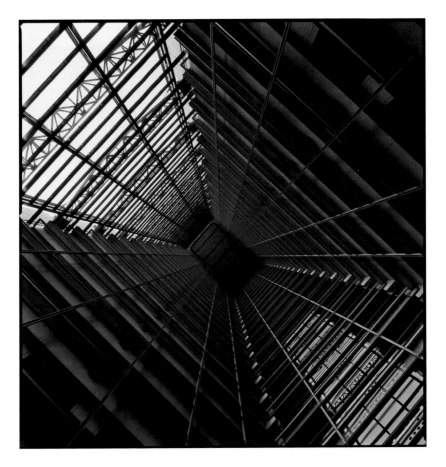

THE FIRE AT SEA

When the tide goes out for the last time, all the shipwrecks will be waiting for us and the bones of the earth will shine bright white in the sun.

When the tide goes out for the last time, I'll meet you by the planes that never made it past Bermuda.

When the tide goes out for the last time, I swear, we will have nothing left to lose.

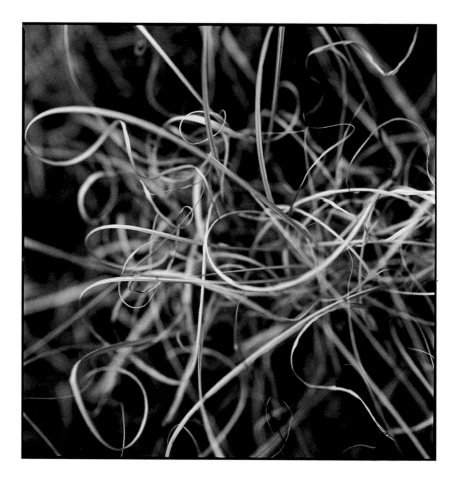

THE BEAUTIFUL MESS WE COULD BE

So may you find in each other what you came here for. And trust that this is love because it is (love is trust). And tangled lives you may lead but into each other, never apart, till you cannot distinguish between being and being together.

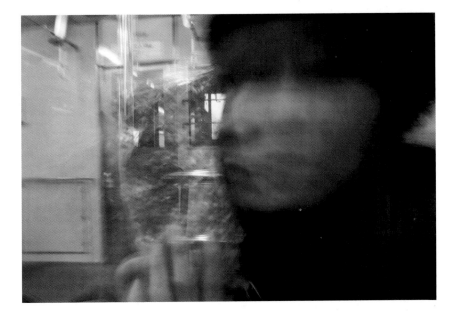

THE TITLE SCREEN

Just pretend you're in a movie. Be as brave and as full of love as the main character.

Because we all need to believe in movies, sometimes.

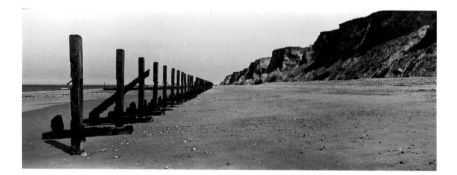

THE BLEACH

You are your hair
and your eyes and
your thoughts. You
are what you look
at and what you
feel and what you
do about it. The
light from the sun
is still a part of the
sun. My thoughts of
you are as real as
any part of you.

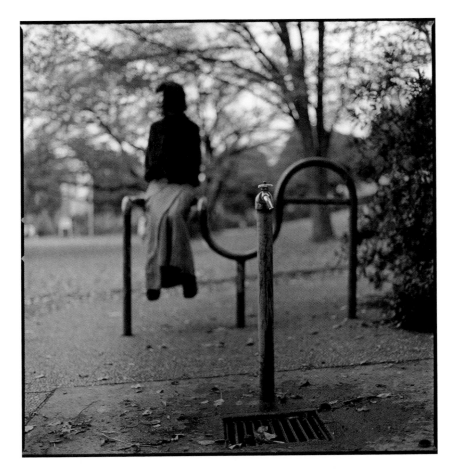

THE STRANGER IN WAITING

I'm sure you've met them. They say they'll put you back together while they're tearing everything apart. And they use the type of lips you can taste for years.

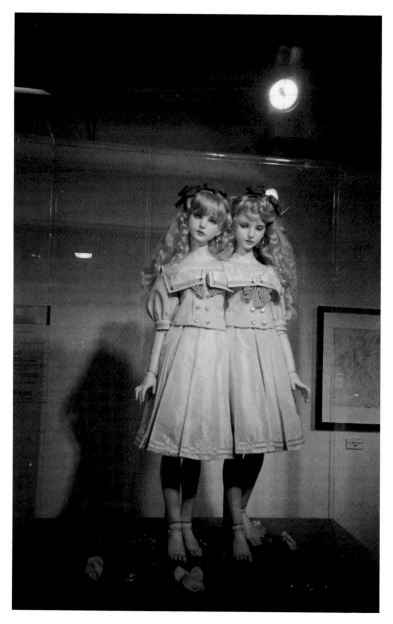

THE HEART WE SHARE

Every time they cut you, I bleed.

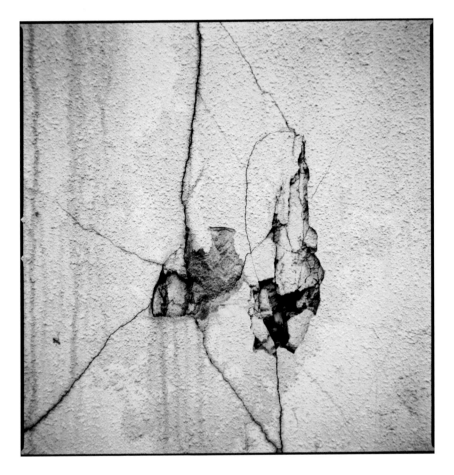

THE ROAD MAP BACK

I missed you more than words and pictures can describe.
But I'll try.

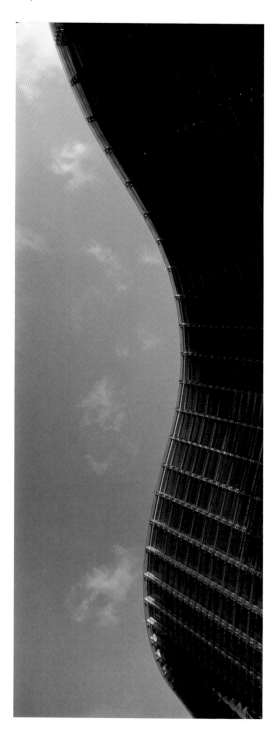

THE SHAPE OF AIR

You love the way air moves. And now I can no longer breathe.

54

THE LIPSTICK ON THE WINDOW

The words "I love you" become nothing but noise. But that's why we kiss. To say with our lips what we couldn't before.

THE ABSENCE OF OXYGEN

Forget the air.

I'll breathe you instead.

THE SCARS YOU LOVE

There are a million ways to
bleed. But you are by far my
favourite.

THE ZODIAC OF ONE

When I look up at night, all the constellations look like you.

THE STATIC ON THE LINE

Don't talk to me like you know me. Talk to me like you love me.

THE TENDER
TINDER BOX

You've made the air
flammable. These
walls are just paper.
And blood is gasoline.
You shouldn't have
come here, made
of fireworks, if you
didn't want me to
play with fire.
I need a light.

THE SLIGHT PINCH

You and I could collide, like atoms in some scientist's wet dream. We could start a new universe together. We could mix like a disease. And if we do, I hope we never get better.

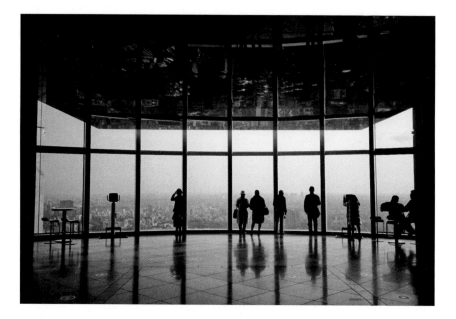

THE WISHING WELL IN THE SKY
(LETTERS TO FATHER TIME)

All I ask is that you let me spend forever feeling this way, before you take me.

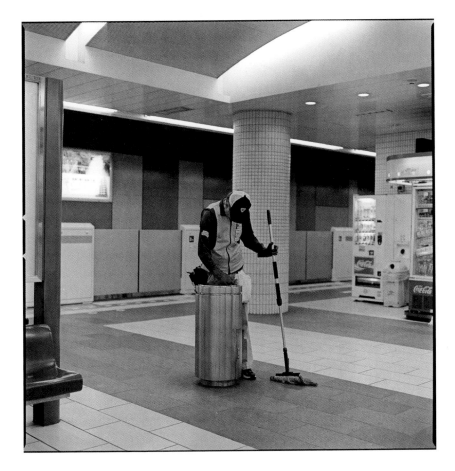

THE HUMANS AREN'T RECYCLABLE

I hold you like I do, tightly because I know that one day, I'll die.

And I am determined to do it with a smile on my face.

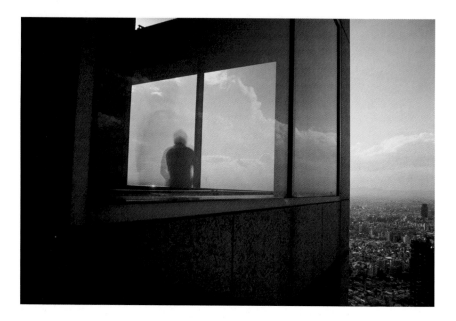

THE PLACE WHERE I WAIT

I'll see you at your funeral, if you'll see me at mine. I'll wait at
the edges for your ghost to rise (until the end of time). We'll find
someplace nice to haunt, an abandoned beach house filled with
memories of summer sunburns. Children will giggle as we tickle
their feet at night and they'll never know the bad dreams we fight.
We'll make our own heaven. Walking in places we used to walk until
death, dies.

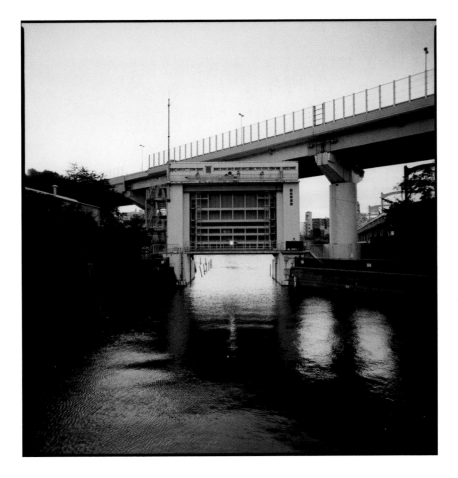

THE EBB AND FLOW

I know I'm only borrowing it. I know I have to give Summer back to you. Just as you, have to give Winter, back to me.

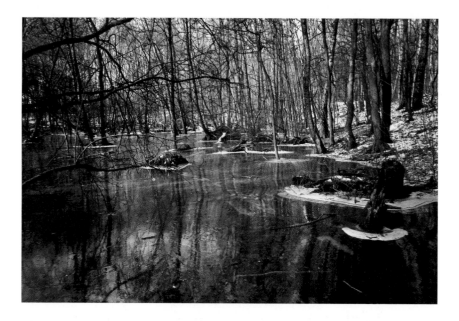

THE POINT PAST PEAK FEELINGS

I know you have feelings left somewhere.

But they're all so hard to reach.

THE PICTURE WE MAKE

The little things you forget, kill me.

THE DIARIES OF FOREIGN LOVERS

You are so patriotic to your heart. It keeps the country together. But it tears the world apart.

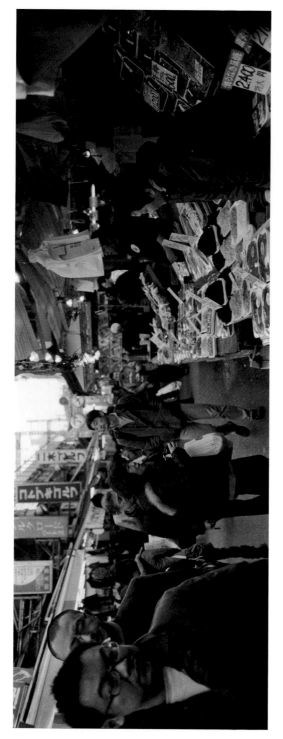

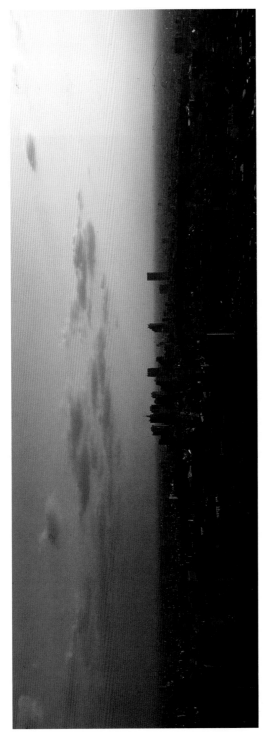

THE LACK OF POSTCARDS

I know you're not here, I can see it in your eyes when we talk. Where ever you are, come back soon.

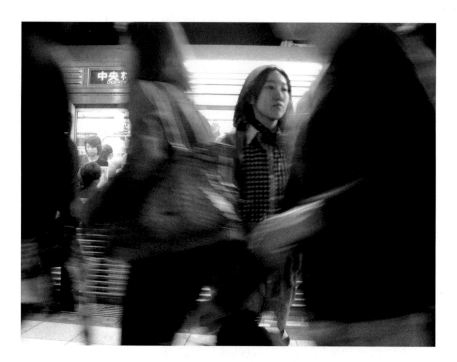

THE TRANSLATION SERVICE

And when I asked you how you'd been I meant I missed you more than I've ever missed anything before.

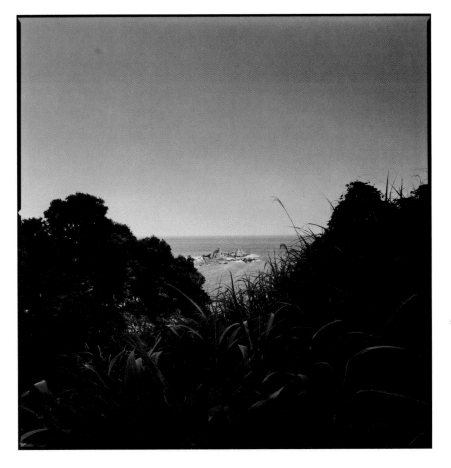

THE FIRST TIME WE MET

It's when you hold eye contact for that second too long or maybe the way you laugh. It sets off a flash and our memories take a picture of who we are at that point when we first know "This is love."

And we clutch that picture to our hearts because we expect each other to always be the people in that picture. But people change. People aren't pictures. And you can either take a new picture or throw the old one away.

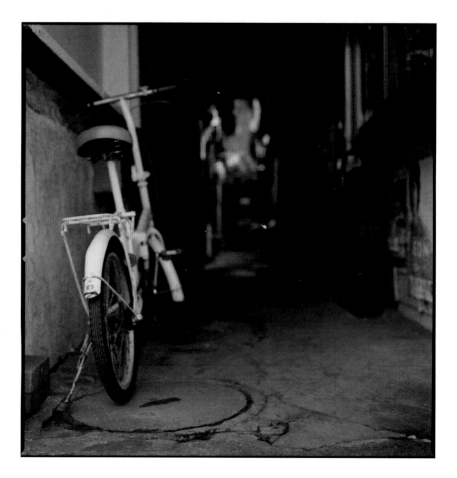

THE AWOL HEARTS

Let's play hopscotch in malls. Let's drive fast with the top down. Let's turn up the music as loud as it'll go. Let's put a couch on an island in the middle of the freeway and wave at everyone on their way to work. Let's hug strangers in parking lots. Let's hand out secret messages at traffic lights. Let's make lists of all the things that make us smile and tick them off, one at a time. The world will carry on without you and me when we're gone.
Let it carry on without us, today.

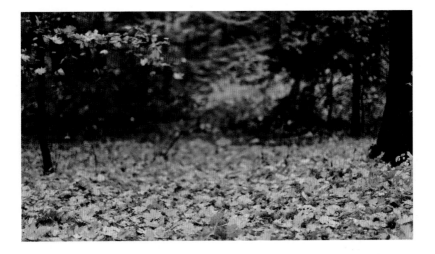

THE FORGOTTEN FEELING

I know there was something before you.

I just can't remember what it was.

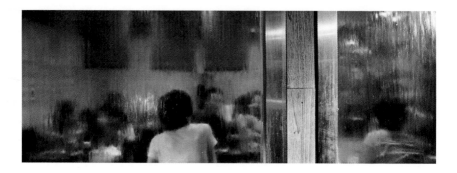

THE FIRST CRACK IS THE LAST

I lied when I told you I forgot. I know it doesn't seem like a big thing but I wanted to tell you the truth and never, ever lie to you.

Because that's how it starts.

STARS,

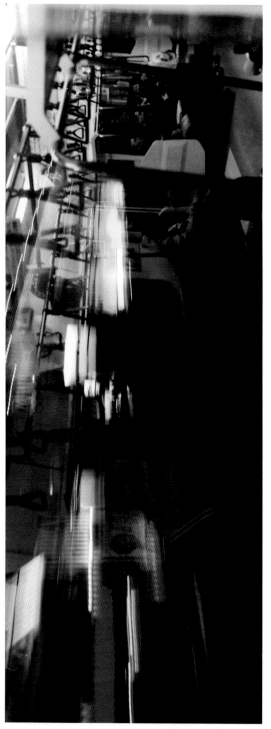

THE PLACE WHERE YOU GET OFF

Outside the station, she stands with her child on the side of the street, taking pictures of cars.

You think she's insane. Until, one day, you notice that she's taking pictures of the license plates of the cars her child gets into.

Because you look. But you do not see.

And she walks out the shop with bags full of cat food. You think she's some crazy cat lady until you find out, she has no cats.

Because you eat. But you do not taste.

It's been a while since their last album but he assures you, he's doing just fine these days, white flecks in his nostrils. Then he asks you if he can spend the night on your couch, even though it stinks.

Because you sniff. But you do not smell.

And they say "Just OK" when you ask them how school was. Then you wonder what they're hiding until you find their diary and the last entry reads "I wish you'd give me some privacy."

Because you listen. But you do not hear.

And they've got a bruise over their eye and you run the tips of your fingers over it and ask them how it happened. You believe them. Until it happens again.

Because you touch. But you do not feel.

And they walk past you everyday, one million stories, each waiting to be told. Waiting for you to ask.

Because you live. But very few, love.

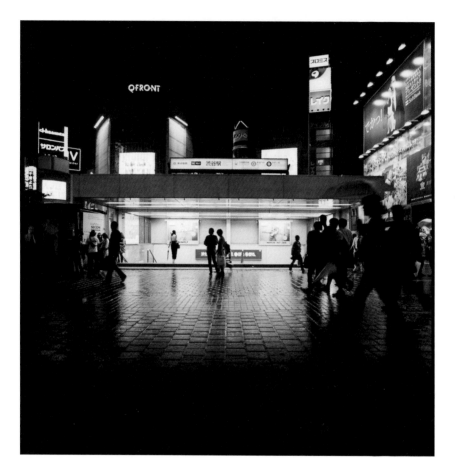

THE BARGAIN

He gave me that night back and this time, I told you the truth. We talked and held each other till the sun came up. And as I went to hell, the devil asked me if it was worth it. I said yes. Yes it was.

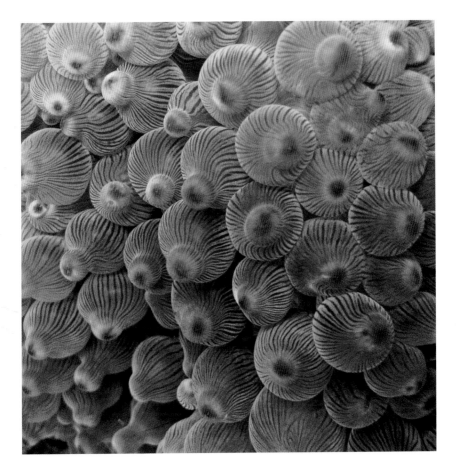

THE SKELETONS IN THE SEA

Truth is the last thing I can take because it's the last thing you took.

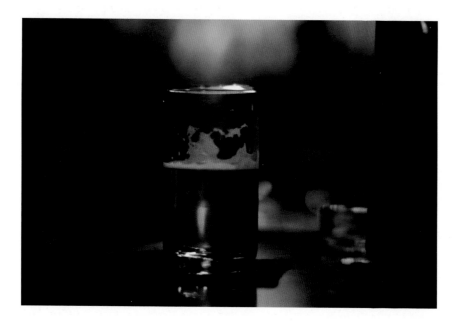

THE FORGOTTEN STAR

You keep telling me to be glad for what we had while we had it. That the brightest flame burns quickest.

Which means you saw us as a candle. And I saw us as the sun.

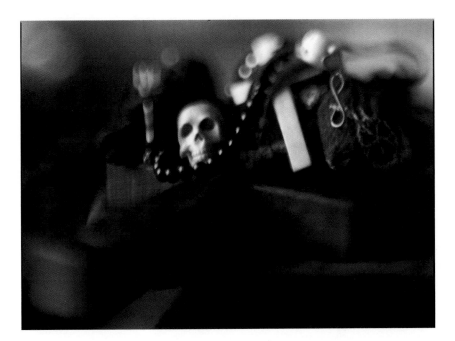

THE SERAPHIM AND THE PIRATE

You were better to the ones that were worse for you. And worse to the one that was better for you.

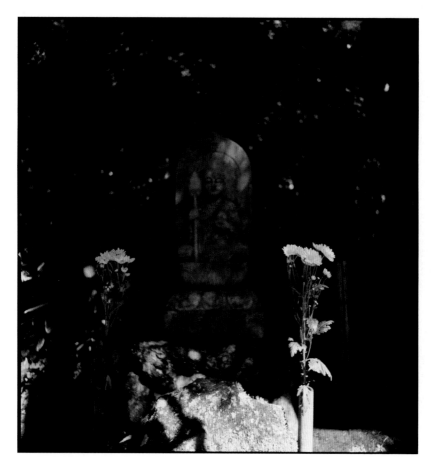

THE ONE I MISS

Just say goodbye. You can say it when you get up from the couch. You can say it at the door. I will say it when you get to your car.

I'll scream it as you drive away.

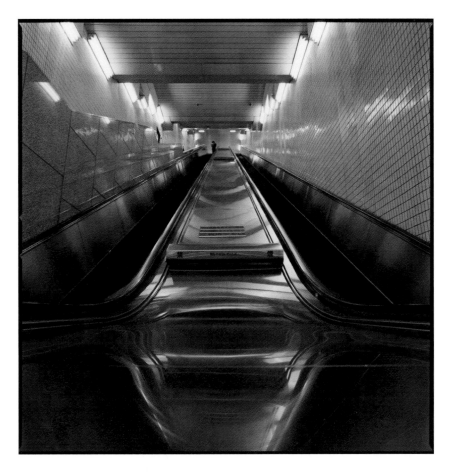

THE STRANGER IN YOU

My parents gave me a book and it told me I was made of dirt and dust. But you, you were made of ash.

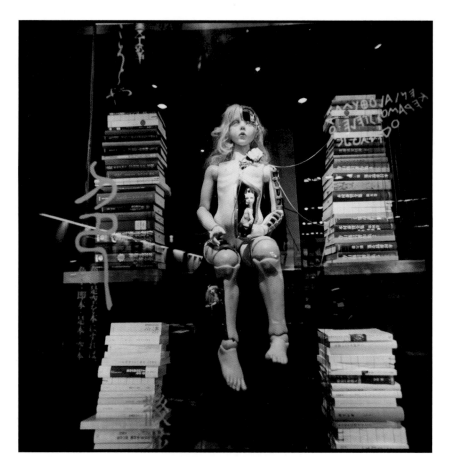

THE LEFTOVERS

I made myself from all the love you no longer wanted.

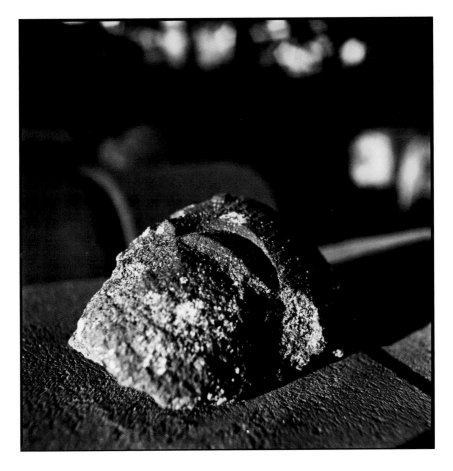

THE END OF THAT

If you thought that was our second chance, you're wrong.

It was our last.

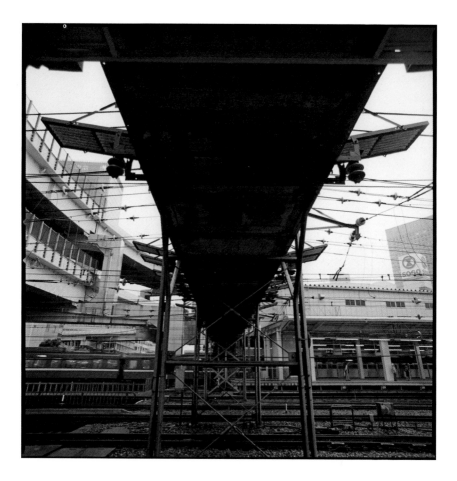

THE BRIDGE FROM SOLITUDE

Just like you mistook lust for love, you have mistaken being alone with loneliness. So I'm fine. Thank you for asking.

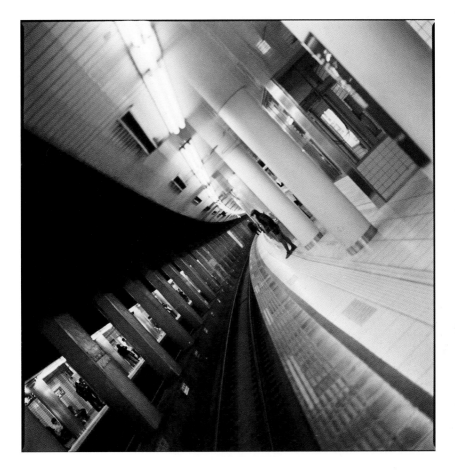

THE SHEER ARROGANCE OF LONELINESS

Making love was never about you and me in a bed.

We made love whenever we held hands.

THE HEART IS RED

I'm sorry. But you could never tell the difference between the mood you were in, and me.

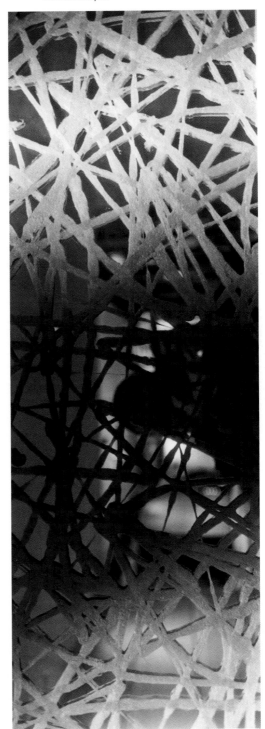

THE BASTARDS TIED ME DOWN

You may continue to call it a breakup. I will continue to call it an exorcism.

THE SHADE

You are no longer here. So please leave.

THE TRUTH IS UGLY

In the movies, the person leaving you never has a blocked nose when they cry. And all their tears are pretty.

THE SKIN I'M IN

This is my skin. It keeps out the rain and words I'd rather not hear like "I'm tired" or "I'm fine" or "We need to talk."

This is my skin and it's thick. This is not your skin. Yet you are still under it.

THE FLOOR TAKES SO LONG TO HIT

Congratulations.

You took me down. And now, you have made everything that is sad, relevant.

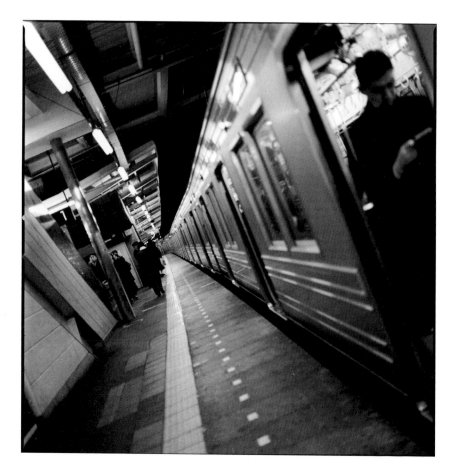

THE CUPBOARD IS EMPTY

I'm all out of midnight phone calls and flowers sent to your door. I'm out of throwing letters off fire escapes and drawing a cathedral in the sand. I'm out of spray-painting your name on freeway overpasses. I'm low on cute names given between blankets and 9 am. I've got no dramatic displays of public affection left. And now everyone else I ever love is going to think me boring. Because I used it all up on you.

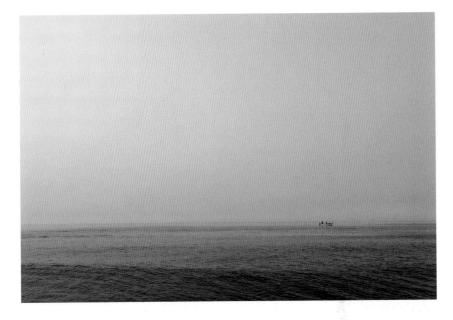

THE TINY ICEBERG

Fine. Maybe I'm the puzzle. But you're still the pieces.

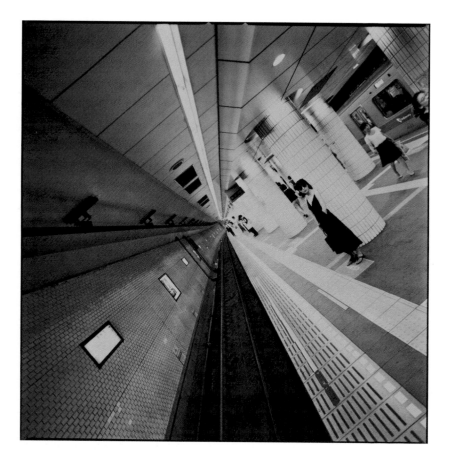

THE B-TRAIN

I'd leave the memory of you at the station, if it didn't already know the way home.

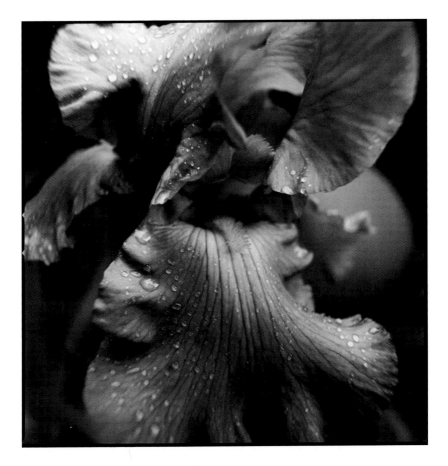

THE ROSE IS NOT ALWAYS A ROSE

You can be in love and you can be in a relationship. But they're not always the same thing.

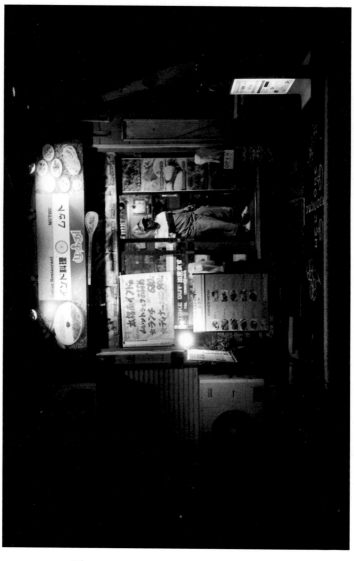

THE MECHANICS OF PUPPETRY

I guess I should say thank you, for cutting all my strings. But if it's all the same to you, I wish you'd left my wings.

THE BYSTANDER PICKS SOMETHING UP

I'm with them because, despite everything, I still love them. And while you might walk in and find me punching a wall, it's only because I want to kiss their lips.

There's no revenge here.

Love doesn't hate back.

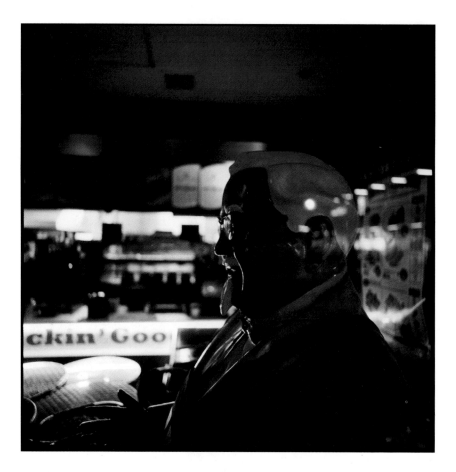

THE LEAVE BEHIND

I don't know who you're kissing now. But I do know who you think about when you do.

THE SIMPLE SHATTERING OF WATER

It's because you and them were made of the same pieces. And afterwards, when you put yourself back together, some piece of them remained.

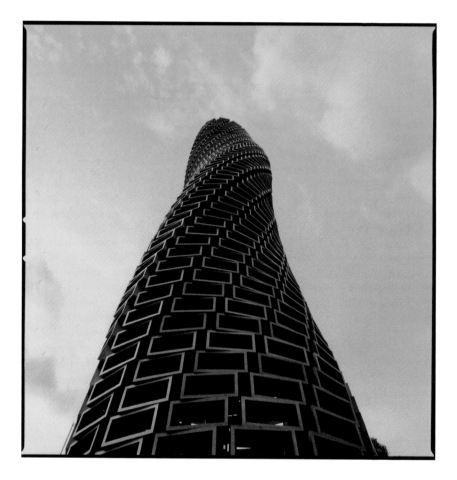

THE GLASS TOWER

Until you are no longer the pictures that chase me down a flight of screens each night. Until the part of me that you first touched, forgets.

THE SEA RECLAIMS THE LAND

I know you're just a rag doll now, sewn together with memories that we might have had.

I know you're just the dream inside of a dream

And don't worry, I know I don't know you, anymore.

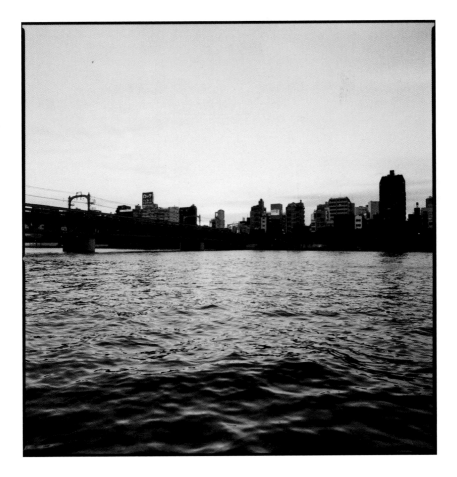

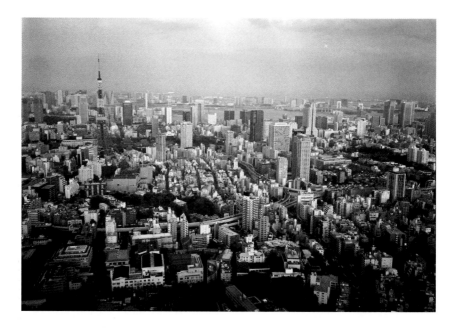

THE WORLD IS TOO BIG

All the space without you in it, is empty.

THE GREEN CURTAIN

How many hearts would be invaded for the wrong reasons, if each time you said "I love you", you meant it?

THE PRINCESS IS IN ANOTHER CASTLE

You cannot go back in time, even if you wish it with every fiber of your being, your heart and soul, even if you think about it every day.

Trust me. I know.

THE MONSTERS I MISS

And every single thing you ever did that bothered me, is every single thing I miss.

THE ERROR OF PARALLAX

The only reason I hate you now is because I loved you then.

THE HISTORY OF ARSON

When you lived here, it was a city. When you left, it became a town.

THE THINGS SOLD BY THE SEA SHORE

I could've sworn I was telling the truth when I told you I didn't miss you.

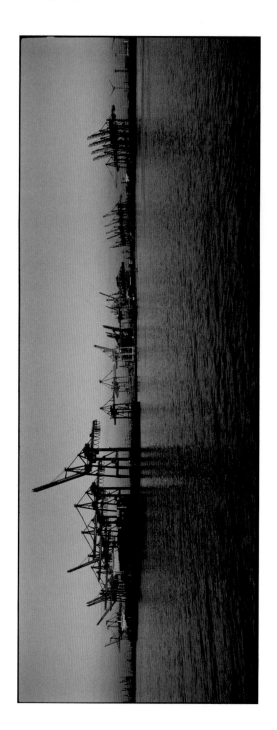

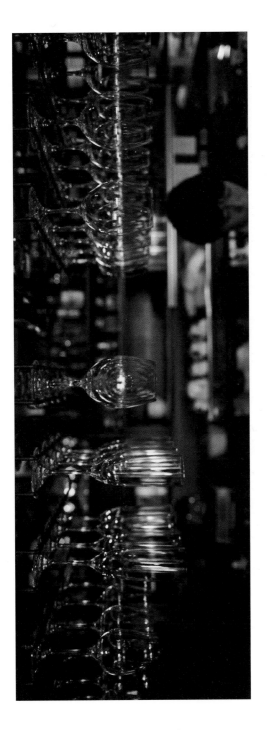

THE TALES FROM BAR

You're just another story I can't tell anymore.

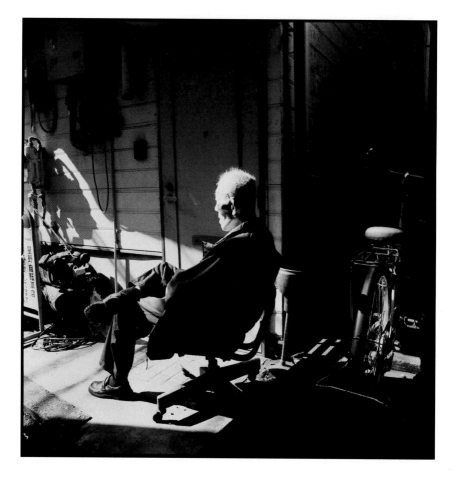

THE LAST DAYS

I just need you to be able to tell people I was here, I felt, I lived and I loved as much as I could, while I could. And that the person that I loved, was you.

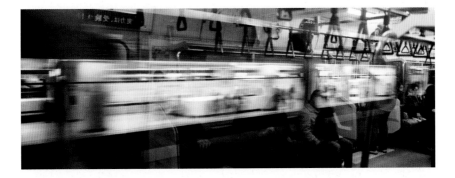

THE SLIPSTREAM WE'RE CAUGHT IN

If time takes me (and time will take me), I will come back as a single feather.

So please come back as a breeze.

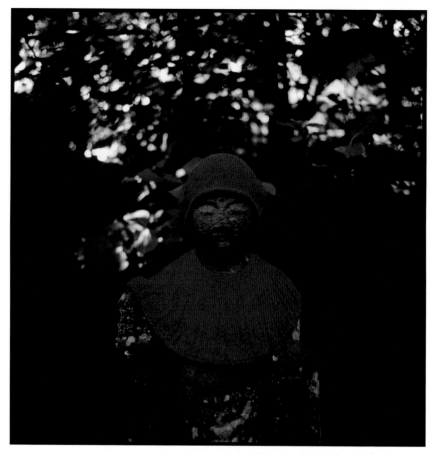

THE DEATH OF LOVE

Oh love. Why is your body so still, why do your muscles sing no more, why does your chest not rise and fall.

Oh love. Why is your skin so cold, why do your eyes not trace my face, why do you not get up and accept my warm embrace.

Oh love. I have no regrets for our mistakes, no heart left to break, for you have taken it with you to the grave.

Oh love. Love that turned to death, death that turned to longing, longing that turned away from me, leaving me here to bear it alone.

Oh love. Oh love. Oh my love.

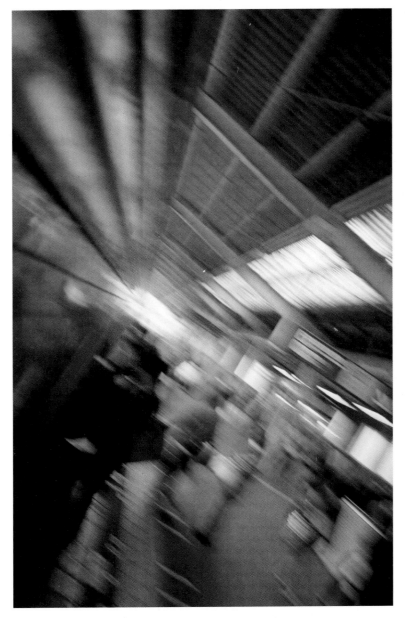

THE MISSING EXCLAMATION MARKS

You're ok. Breathe. Just breathe. Open your eyes. Come back. It's ok. It's over now. You're ok. Wake up. Please wake up. Don't do this to me. Don't do this to me. Don't do this to me. I love you so fucking much. Come back.

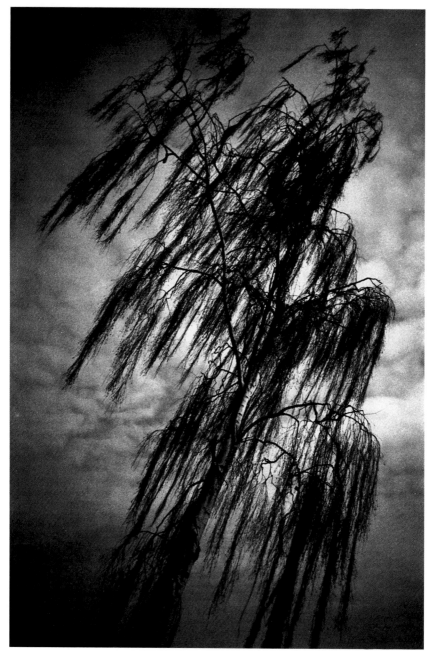

THE LYING TREE

The least you could do, is uncross your heart. Unhope to die.

THE DAY AFTER THE CRASH

The sun still, surprisingly, came up and shone down onto the cold, metal leftovers. No loud noises. No screams. No breaking glass. Just silence and sunshine. You would be forgiven for thinking that this all happened on another planet. It didn't.

THE FUTURE IS THE PAST WAITING TO HAPPEN

And though you may not be able to imagine what I was like, I did live.
More importantly, I loved.

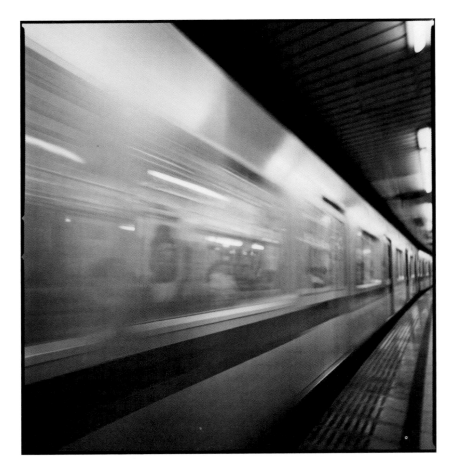

THE NEXT STOP

Only because it's still so raw and real. Soon I'll just be a series of images that sometimes flash through your mind, when you least expect it. And after that, only a few will stay.

Then, one. A memory of a memory.

THE SUN OR THE MOON

Things change the way you feel. And things change.

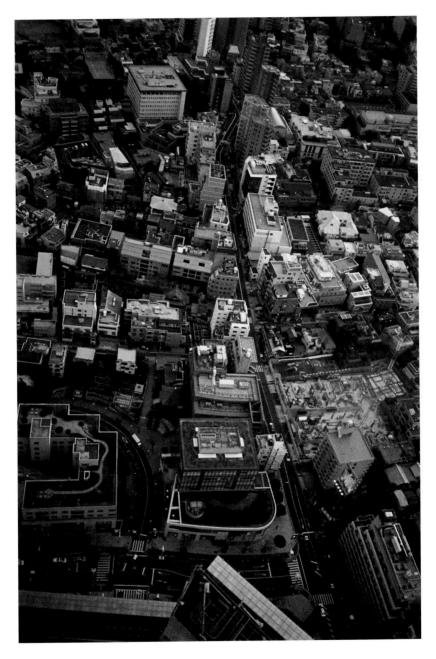

THE CITY RISES AND FALLS

You were a dream. Then a reality. Now a memory.

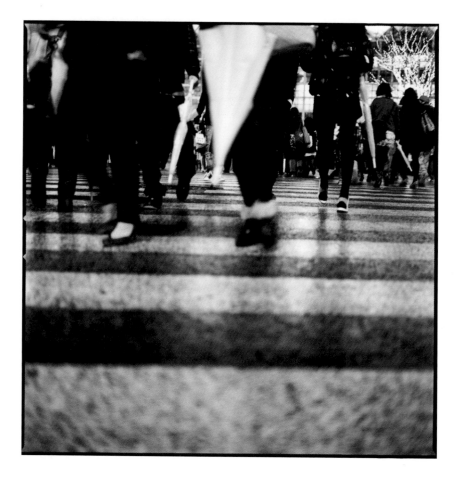

THE BLUE LINES

I couldn't convince you that the blue
you see is the same blue that I see.
But maybe that's how lovers know
they're meant to love; they see the
same blue. And they both know it.

THE WATER IS ON FIRE

I'm not scared of never meeting
you. I'm scared of having met you,
and let you go.

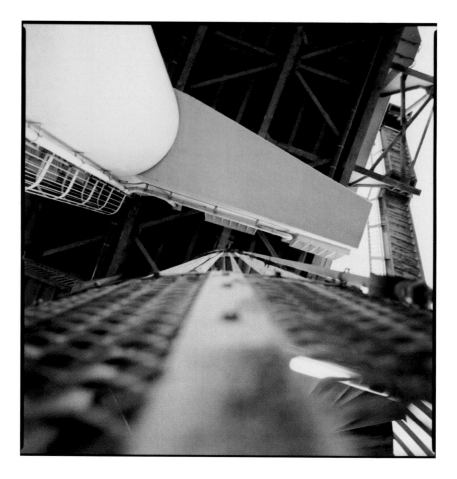

THE SECONDS BEFORE LAUNCH

This isn't me missing you. This is me missing the me I used to be.

This isn't me.

THE GRIM ALTERNATIVES

I love no one but you, I have discovered, but you are far away and I am here alone. Then this is my life and maybe, however unlikely, I'll find my way back there. Or maybe, one day, I'll settle for second best. And on that same day, hell will freeze over, the sun will burn out and the stars will fall from the sky.

THE PROMISE SLEEP MADE ME

Every bed without you in it, is broken.

THE THEORY IS STILL JUST A THEORY

And if I blink my eyes enough, maybe I will wake up and you will still be there sleeping next to me.

THE TICK-TOCK IN YOUR CHEST

I will hold you so tightly and carefully when I see you again. Like crystal. Or an atom bomb.

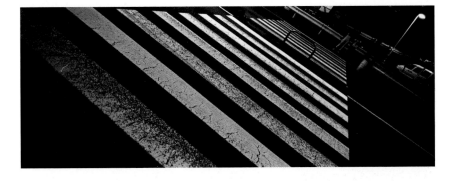

THE FRAGMENTS
BELONG TOGETHER

Things just break
sometimes. Maybe we
should blame that third
person we became, that
personality we shared
together. Maybe it's their
fault because you're a good
person and I think I'm a
good person too. We just
weren't made for this.

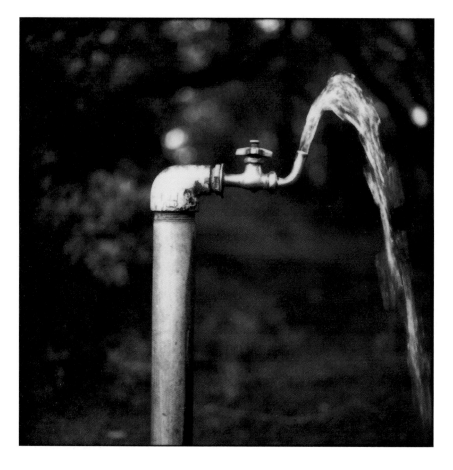

THE WATER FLOWS UPHILL

The heart is a muscle like any other and the best exercise you can do for it is called picking yourself up off the floor.

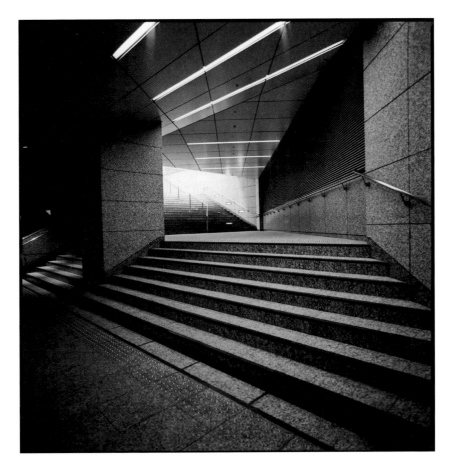

THE FADING GLOW

What you gave me was a reason. Not an excuse. Because there's sex, making love and fucking. And then there's you.

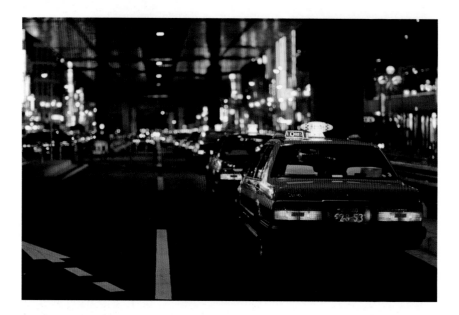

THE TWINS

I like to think that somewhere
out there, on a planet exactly like
ours, two people exactly like you
and me made totally different
choices and that, somewhere,
we're still together.

That's enough for me.

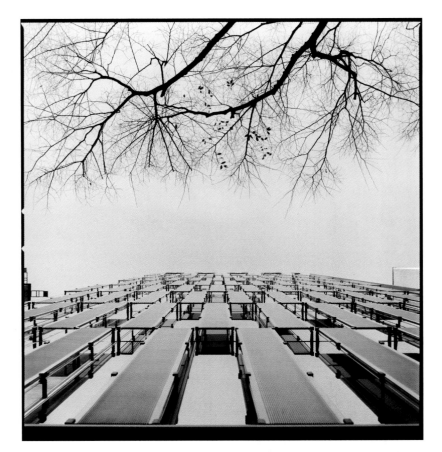

THE EMPTY CLASSROOM

You taught me how to be alone.

And I learned my lesson, in your absence.

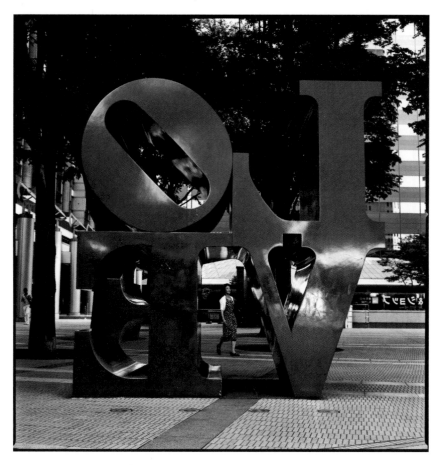

THE WORLD IS BETTER BACKWARDS

I never saw you again. You slammed the door as you came in. We yelled at each other about something that just shouldn't fucking matter but for some reason, it does. It happened. We spoke softly. We were in bed. I told you

"I love you."

You said the same. We went to movies and parties and friends and ate and drank and made love.

It all ended with my eyes meeting yours for the first time and the sudden, extreme feeling of expectation.

And now, how can I miss what has never existed.

RAIN.

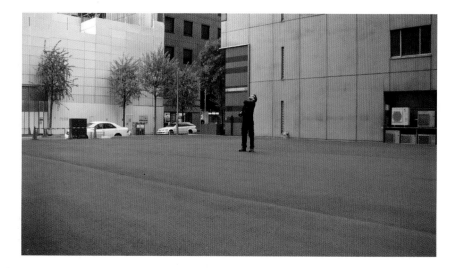

THE ANGEL OF ALMOST

Then I was somewhere else, and it was bright. A voice said

"If you'd carried on practicing that song you almost got right, you would've been great. Bigger than the Beatles."

It continued

"If you'd carried on working on that book you almost finished, it would've changed the lives of many, many people."

Then it said

"If you'd tried to reach the one you loved just a little bit more, when you almost had them, your life would've been completely different."

And I asked

"Is this what happens when I die?"

And the voice said

"Almost."

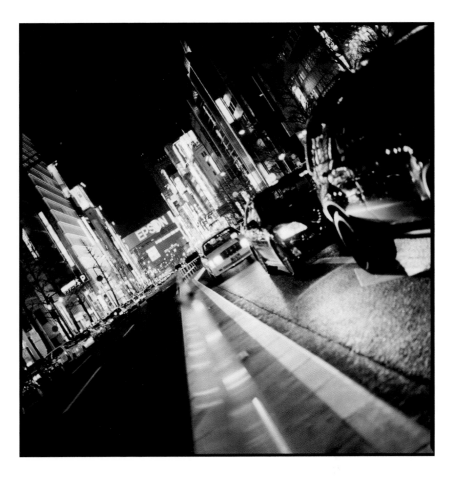

THE BEST WAY TO RUN INTO TRAFFIC

It does not count if you believe in yourself when it's easy to believe in yourself. It does not count if you believe the world can be a better place when the future looks bright. It does not count if you think you're going to make it when the finish line is right in front of you.

It counts when it's hard to believe in yourself, when it looks like the world's going to end and you've still got a long way to go.

That's when it counts. That's when it matters the most.

THE HOPE OF SYMMETRY

So you look for patterns because that's what humans do to try and make sense of things. In hope of some divine order. And you look in movies and songs and the things that you read for symbols, points and swirls that match your own. But the only real pattern there is, is the one you make when you hold up a mirror. And reflect.

THE CATWALK
IN THE SKY

And it may look to you
like I'm just walking
through your city with
my head held high.

But in my head, I am
not in your city.

THE MEDICINE IS THE SICKNESS

If there's one thing I hate, it's people who won't let me in on the freeway.

If there's one thing I hate, it's having to let people in on the freeway.

If there's one thing I hate, it's waking up to 50 assholes pretending to be me.

If there's one thing I hate, it's waking up feeling like an asshole because I yelled at those assholes.

If there's one thing I hate, it's people who turn the things I say into insipid greeting card messages.

If there's one thing I hate, it's turning a bunch of ideas into a laundry list.

If there's one thing I hate, it's that feeling you get when you scratch something new.

If there's one thing I hate, it's not knowing what's wrong with someone and all you want to do is make them feel better.

If there's one thing I hate, it's knowing that my mind naturally gravitates towards the negative and not being able to stop it.

If there's one thing I hate, it's people who become your friend, to become your friends' friend.

If there's one thing I hate, it's being really busy and using that as an excuse to ignore your email.

If there's one thing I hate, it's having to acknowledge that my feelings are my own, no one else's. And, my responsibility.

If there's one thing I hate, it's forgetting that and taking the way I feel out on the world.

If there's one thing I hate, it's people who criticise things, who can't take criticism.

If there's one thing I hate, it's going to the same job day-after-day for the same pay.

If there's one thing I hate, it's not having a job.

If there's one thing I hate, it's not you.

It's me.

THE FRAGMENTS OF HOPE

Dear Future You,

Hold on. Please.

Love,

Me.

Dear Current You,

I'm holding on. But it hurts.

Love,

Me.

Dear Past You,

I held on. Thank you.

Love,

Me.

THE REASON THE WILLOW WEEPS

It weeps for you late at night, when sleep does not come easily. It weeps for the one you miss. It weeps for the dreams on the tips of your fingers. It weeps for appointments missed and it weeps for the tears in your pillow. It weeps for the silence and it weeps for the noise. It weeps for formal letters where once, language was spoken as close to your ear as possible. It weeps for betrayal, intended or not. It weeps for the friends you once were. It weeps for the colours faded. It weeps for sunrise. It weeps for a death in the family and it weeps when a baby is born. It weeps for the last time you touched. It weeps for words that can never be taken back. It weeps so hard and so much and so often. So you don't have to. So you can carry on. It weeps for you. When you have run out of weeping.

THE LACK OF APOLOGIES

No matter how you stack me. No matter how you arrange me. No matter how you look at me. I am still here and I am still the same person made of the same things. I regret nothing.

THE TRUTH BEHIND GLASS MOUNTAINS

This isn't torture.

Torture happens in small, dark rooms in countries with names you struggle to spell.

This is just mildly unpleasant.

This isn't heroism.

Heroism happens in churches that are also schools, performed by teachers with no names and no place to stay.

This is just a good deed for the day.

This isn't loss.

Loss happens on fields filled with poppies, in hospitals buzzing with flies, in distant deserts and late at night when there's no good reason for the phone to ring.

This is just longing.

This isn't important.

Important happens on bended knees and is breathed on last breaths with hands clutched tight, hearts tighter.

This is just a distraction.

THE FLOWERS OF 3753 CRUITHNE

Truly great people were once called weird so that today, you aren't called anything.

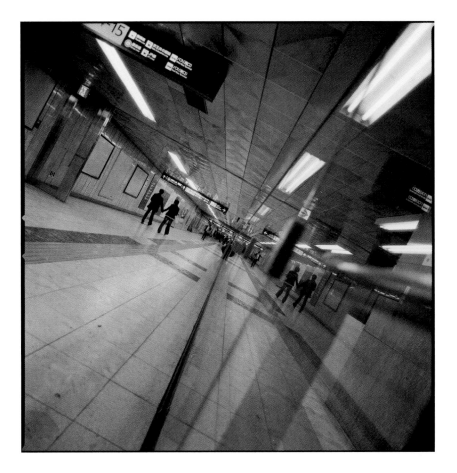

THE NEED FOR HONESTY AFTER MIDNIGHT

Not the first one in the morning or the one on the TV, the well-meaning phone call on a Monday night one or some you find on the radio — the voice that whispers between your ears before you fall asleep, that's the one you pay attention to.

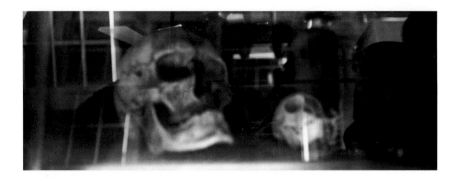

THE PLACE SENTENCES GO TO DIE

No one knows where the words come from and if someone tells you that they do, they're lying.

THE PEOPLE WE COULD BE

Being gifted doesn't mean you've been given something.

It means, you have something to give.

THE INSCRIPTION

This is how I live. This is how I live. This is how I live.

I mumble things under my breath, three times so I'll remember.

This where I live. This is where I live. This is where I live.

Inside the sun, beneath the burning trees.

This is how I love. This is how I love. This is how I love.

Touching you, in case there comes a time I can't.

This is where I love. This is where I love. This is where I love.

In the heart of things, on the tips of waves.

This is how I die. This is how I die. This is how I die.

Too fast, not long enough.

This where I die. This is where I die. This is where I die.

Here.

THE WOOD IN TREES

You constantly look for a sign and when it's given to you and you don't like the answer, you call it a coincidence. There are no coincidences.

THE RED SKY AT NIGHT

Today, no planes flew into any buildings.

Today, there was no fire falling from the sky.

Today, there were no riots in the streets.

Today, the news was mostly just about famous people.

Today, no shaky footage was recorded of children running from a burning village.

Today, not one person stood in front of a tank.

Today, no one put flowers in the rifle barrels of guns.

Today, you will check your mail.

Today, no shots rang out over a black cavalcade.

Today, there was no negotiated revolution.

Today, no flags were burned.

Today, sport will be played and people will be upset over the outcome.

Tomorrow however, is a new day.

THE AMOUNT OF PEOPLE WHO LIKE THIS

And now, no matter where you go, you can look at a screen and see what one thousand other people like.

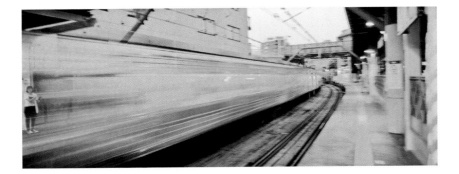

THE NOD AND THE WINK

Time never said

"Best you enjoy yourself now because we're going somewhere soon."

But that's what he meant.

THE FEW AND FEWER

You can make the world beautiful just by refusing to lie about it.

THE RETURN TO GREEN

Oh shut up. Every time it rains, it stops raining. Every time you hurt, you heal. After darkness, there is always light and you get reminded of this every morning but still you choose to believe that the night will last forever. Nothing lasts forever. Not the good or the bad. So you might as well smile while you're here.

THE ENVY OF WISHES

You wake up with a list of all the people you'd rather be.

But you're already on everyone else's list.

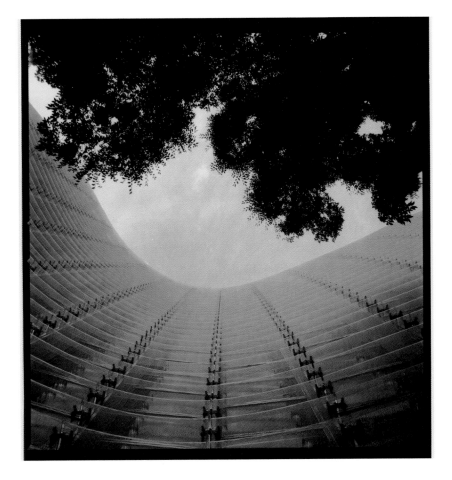

THE NATURE OF MY BODY

That sound you hear, that's the sound of someone realising that sometimes, it's easier to change the world than it is your own life.

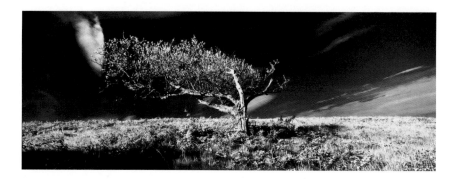

THE GHOST FARM

To you, it was just picking flowers. To them, it was a massacre.

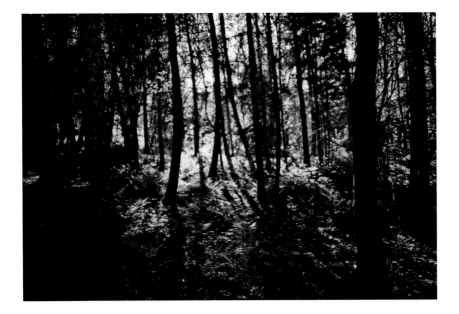

THE RATIO OF LIFE TO LIVING

Oh sure, some people give a little bit each day. But there are one or two special souls who, when you least expect it, give an entire life's worth all at once.

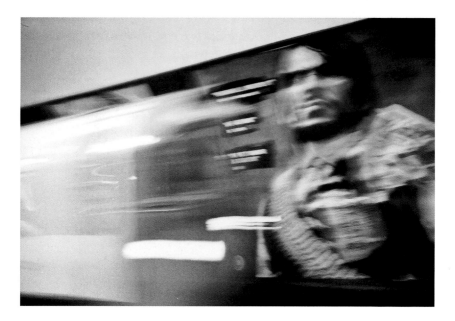

THE REFRACTED NIGHT

You forget that, in the dark, we must move closer together in order to see each other. You were never alone.

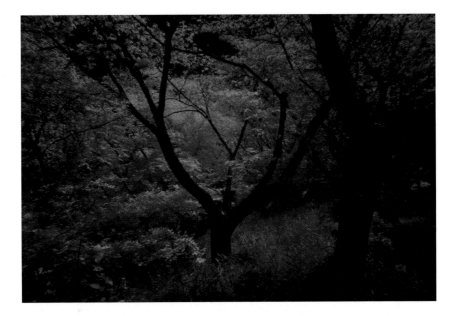

THE METRONOME TREE

Forget about your lists and do what you can because that's all you can do. Phone up the people you miss and tell them you love them. Hug those close to you as hard as you can. Because you are always only a drunk driver's stupidity, a nervous shopkeeper's mistake, a doctor's best attempts and an old age away from forever.

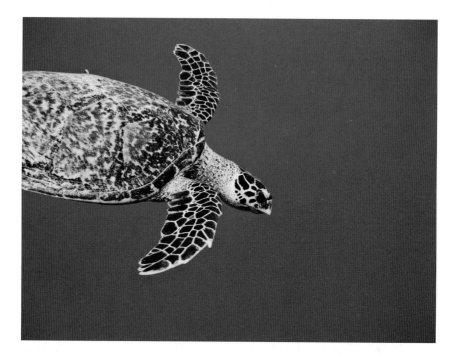

THE HARDEST YOU COULD BE

And you will find no fear here, in unkind words or the hardness of others.

And you will find no sadness here, in the meanness of the world, in the anger that comes from those who feel small.

And you will find no hurt here, in a million insults or a single, softly spoken lie.

Because only a hard heart shatters.

Only a hard heart, breaks.

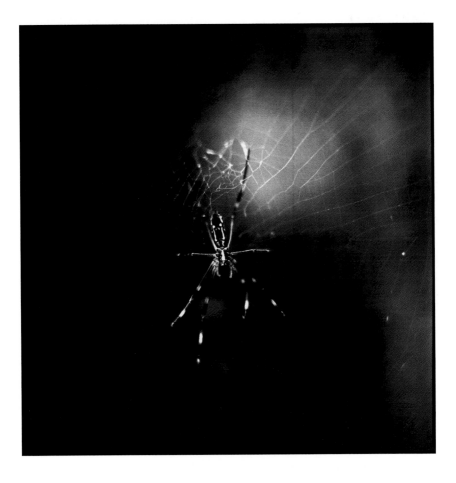

THE DWINDLING CONVERSATION

"You're beautiful."

Replied the fly, to the spider.

THE OROBORUS I FELL IN LOVE WITH

Where you are, right here and now, this is how bad stories end. But it's also how the best stories, begin.

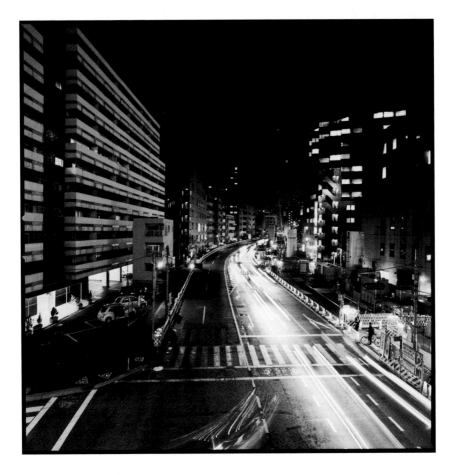

THE CHAMELEONS LIVE IN THE CITY

I guess you're proud of yourself for not trying to change me, even though all I ever wanted to do, was change.

THE WALL OF DAYS

You will never meet anyone who has done something great who waited for permission to do something great.

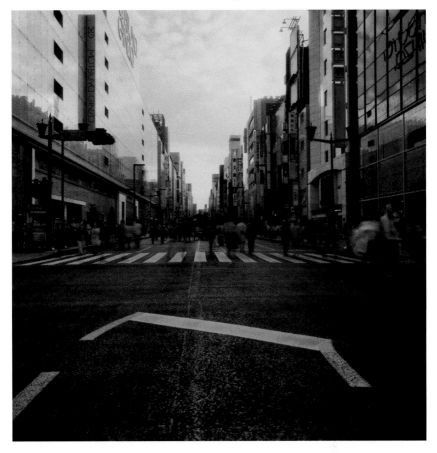

THE LIST OF CHANGES

We can answer any question we have, like how do actors make themselves cry, so we never sit in wonder and wonder at the wonder of the world, anymore.

And anything we watch can be paused, so we never argue about what just happened while we were talking, anymore.

We cannot hope that we might have just missed their call, because our phones are always with us and if they didn't call, they didn't call.

No protests in the streets, just a button marked 'like'.

No one reads stories aloud, unless you are a child.

No letters. Just bills.

THE VIEW ON THE WAY DOWN

All the hardest, coldest people you meet were once as soft as water.

And that's the tragedy of living.

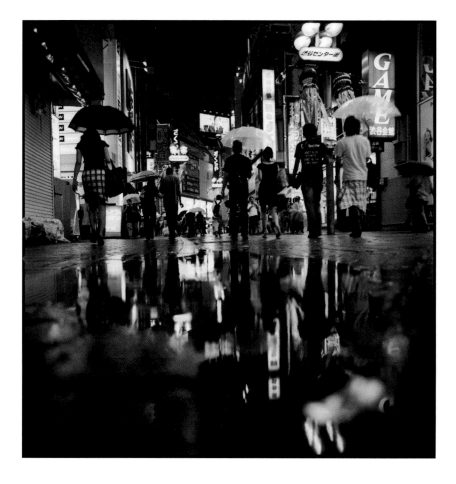

THE WAY YOU LIE HERE

Don't you dare tell me nothing matters. Everything matters. Every fucking drop of rain, every ray of sunlight, every wisp of cloud matters and they matter because I can see them and if I can see them then they can see me and I know that there's an entire world that cares out there, hiding behind a world that doesn't, afraid to show who it really is and with or without you, I will drag that world out of the dirt and the blood and the muck until we live in it. Until we all live in it.

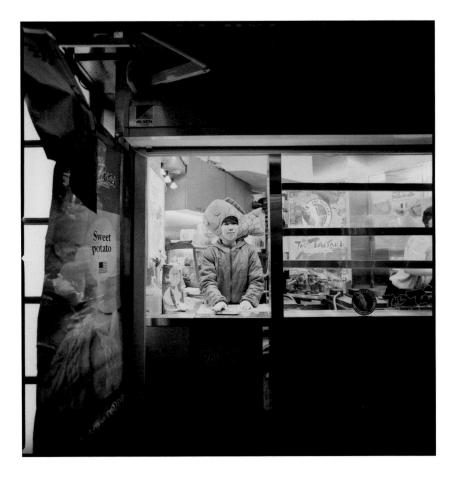

THE PLACE EVERYONE WORKED

If you don't think I'm important, you're a no one, not a someone. Because everyone is important to someone.

THE MOTHS ARRIVE IN BLACK AND WHITE

The bad news is, people are crueler, meaner and more evil than you've ever imagined.

The good news is, people are kinder, gentler and more loving than you've ever dreamed.

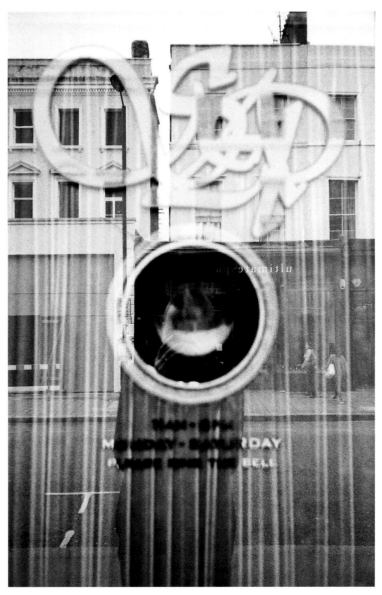

THE AUDIENCE OF ONE

You're too pretty to be weird and too weird to be pretty.
And you feel strange when people try to talk to you. So get a job, it's safer than art. Maybe people won't point and stare so much. Even if they're only in your head. Especially if they're only in your head.

THE SWEET RELEASE

If you blur your eyes, the streetlights become hundreds of ghosts going home.

THE TREES THAT DECIDED NOT TO DIE

As I put down my pen, I know someone, somewhere is picking up theirs.

I know that someone, somewhere is playing a guitar for the first time.

I know that someone, somewhere is dipping a paintbrush and marking a field of white.

I know that someone, somewhere is singing a song that's never been sung.

Perhaps someone, somewhere will create something so beautiful and moving, it will change the world.

Perhaps that somewhere is here.

Perhaps that someone, is you.

THE SAVIOUR GOT LOST IN THE MIRROR

If the only reason you help is so that you can tell people that you help, I don't need your help.

THE RAIN WAS ONCE A CLOUD

Know someone as much as you can. Hold onto the moments that define them. Then when their body leaves, they won't.

THE BLOOD RED LIE

The best time to reflect is when you like the person looking back.

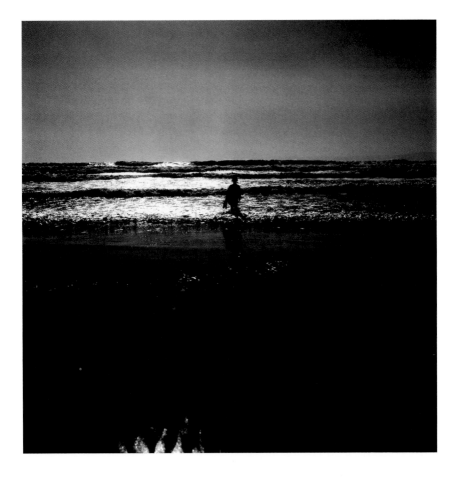

THE MOMENT MY SKIN BRUSHED AGAINST YOURS

But really, all we want, and I speak for the entire human race here, is contact. Someone to let us know that we aren't alone. That the world isn't a dream and you and I really are happening at the same time, even if it's not in the same place. That this is real. You're really there. I'm really here. We're real.

This is real.

THE PACKAGING OF PEOPLE

"But this is just another box."

"No it's not, it's the box we put you in if you say 'Don't put me in a box.'"

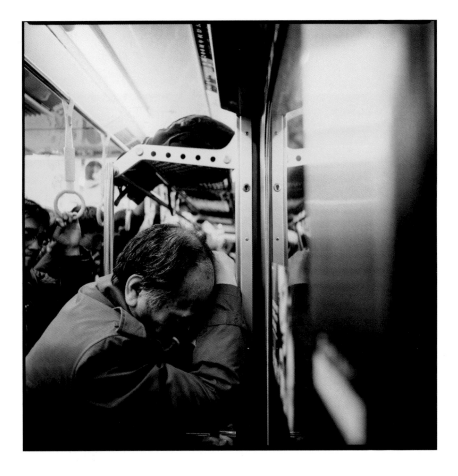

THE DEFENDERS OF THE FORGOTTEN

You are nobody's hero. And nobody needs you. Desperately.

THE PRESSURE TO THE WOUNDED

You know I just wouldn't be human if I didn't try and hold your hand as it disintegrated from the light of a thousand suns somewhere above Hiroshima. Or kiss the tears from your cheeks in Iraq, like the sweat from your brow in Zimbabwe. It isn't in me not to try and lift the rubble crushing you in Gaza or hide you in Rwanda. Like a last hug in a building in New York or the water we shared in Afghanistan. More than the blood we mixed in Flanders or the sandy beach we trod in Normandy. Longer than the fires burned in Dresden or Soweto. I won't let go of your hand.

THE PLACE I'M IN

You cannot kill me here. Bring your soldiers, your death, your disease, your collapsed economy because it doesn't matter, I have nothing left to lose and you cannot kill me here. Bring the tears of orphans and the wails of a mother's loss, bring your God damn air force and Jesus on a cross, bring your hate and bitterness and long working hours, bring your empty wallets and love long since gone but you cannot kill me here. Bring your sneers, your snide remarks and friendships never felt, your letters never sent, your kisses never kissed, cigarettes smoked to the bone and cancer killing fears but you cannot kill me here. For I may fall and I may fail but I will stand again each time and you will find no satisfaction. Because you cannot kill me here.

THE GROUND WILL GIVE WAY

The bad news is, your choices and intentions, some people and places, those nights spent awake and all you've done, can lead you to the bottom of the pit.

The good news is, this wouldn't be the first time someone's crawled, tooth and nail, out of hell.

THE WORLD NEEDS MORE LIGHTHOUSES

You can join the millions talking in the dark.

Or you can stand up and scream light, out into the night.

THE GREAT BURNING OF SUPPER

It sounds pretty but I disagree. I believe there are moments in your life when you have to dance like everyone is watching.

THE BUBBLES ARE YOUR FRIENDS

And though the waves might bring you down and though the currents might pull you under, the sky is always still right above you. And your friends will show you the way.

THE PERFECT APATHY

You remember and dwell on all the things you've lost and ignore all the things you haven't. Because your scars are like stars. Yet the night stays perfectly black.

THE FINITE CURVE

You will only be hurt a finite number of times during your life.

You have an infinite number of ways to deal with it.

THE SHOP THAT LETS YOU RENT HAPPINESS

"This is the one." The universe assures me from behind the counter.

"But I thought you said the last one was the one." I reply.

"No." Says the universe. "I sold you that one so you would know that this, this is the one."

"Is there another one?" I ask the universe.

"I can't tell you." They reply. "It'd ruin the surprise."

THE DAY YOU READ THIS

On this day, you read something that moved you and made you realise there were no more fears to fear. No tears to cry. No head to hang in shame. That every time you thought you'd offended someone, it was all just in your head and really, they love you with all their heart and nothing will ever change that. That everyone and everything lives on inside you. That that doesn't make any of it any less real.

That soft touches will change you and stay with you longer than hard ones.

That being alone means you're free. That old lovers miss you and new lovers want you and the one you're with is the one you're meant to be with. That the tingles running down your arms are angel feathers and they whisper in your ear, constantly, if you choose to hear them. That everything you want to happen, will happen, if you decide you want it enough. That every time you think a sad thought, you can think a happy one instead.

That you control that completely.

That the people who make you laugh are more beautiful than beautiful people. That you laugh more than you cry. That crying is good for you. That the people you hate wish you would stop and you do too.

That your friends are reflections of the best parts of you. That you are more than the sum total of the things you know and how you react to them. That dancing is sometimes more important than listening to the music.

That the most embarrassing, awkward moments of your life are only remembered by you and no one else. That no one judges you when you walk into a room and all they really want to know, is if you're judging them. That what you make and what you do with your time is more important than you'll ever fathom and should be treated as such. That the difference between a job and art is passion. That neither defines who you are. That talking to strangers is how you make friends.

That bad days end but a smile can go around the world. That life contradicts itself, constantly. That that's why it's worth living.

That the difference between pain and love is time. That love is only as real as you want it to be. That if you feel good, you look good but it doesn't always work the other way around.

That the sun will rise each day and it's up to you each day if you match it. That nothing matters up until this point. That what you decide now, in this moment, will change the future. Forever. That rain is beautiful.

And so are you.

THE ARRIVALS LOUNGE

A plane landed and a man in a scruffy coat leaned forward and wondered if this was the one. People got off and walked into the large, gleaming white terminal, where they were either met by others (some in tears but everyone smiling) or if no one was there to greet them, they looked around, shrugged, sat down in one of the long rows of aluminum chairs and either listened to music or read a book or just stared off into the distance in the kind of shell shock that normally comes from long distance travel. Several made phone calls. One, for whatever strange reason, tried to go back through the gate, to get back on the plane. Security, gently, held him at bay.

The old man had seen it all before but he didn't mind waiting. He'd gotten quite good at it. There were exactly 128 chairs in terminal D. The roof had exactly 864 crisscrossing tiles. The planes landed every 11 hours, 59 minutes and 59 seconds. He knew. He'd had enough time to count. He read the paper. It was always the same paper, but each day, there was always a different story about someone he knew on the front page.

Exactly 11 hours, 59 minutes and 59 seconds later, he was too absorbed in the paper and the lullaby of the announcer coming over the terminal speakers to notice the small, diminutive female form standing next to him.

"Hello." She said.

He looked up from his paper.

"I think I know you."

"Yes, I think you do," he replied.

"You once swapped your last packet of cigarettes for a bicycle, in the middle of the war, then rode it for five hours to see me."

"I think that was me. I can't remember. I think we ran a grocery store together. I remember cobblestone streets and a newsagent next door. The children would buy comic books. There was a harbour."

"I think that happened."

There was a silence.

"How was your flight?" he finally asked.

"Good. There was some turbulence towards the end but other than that it was fine."

She rubbed her arms.

"Did you get everything done that you needed to do?"

"Quite a bit. Most of it I think."

"Well, that's all you can really ask for."

"I suppose so. The tea was nice."

"That's good then," he said with a smile.

"Are we supposed to get a taxi now?"

"No, not yet I don't think."

"Then what do we do?"

He cleared some space next to him on the aluminum chair then took his coat off and scrunched it up to make a pillow.

"I think we're meeting someone."

"Oh. Will we have to wait long?"

"No. Not in the greater scheme of things. They serve tea, just ask for one when the woman comes round with the tray."

"Is it good?"

"The best you've ever tasted."

By the time the next plane landed, she'd fallen asleep on his shoulder.

THE LAST THING YOU SAID

As you lay dying, we asked if there was anything else you wanted us to include in the book before we sent it back to you.

"Love, at every opportunity you are given to love. Be less afraid. Embrace each day (none are promised). Cry when you need to, it'll make you feel better. You were put on this planet to feel every feeling you could, do that. Everything works out in the end.

I promise."

BY IAIN S. THOMAS

I WROTE THIS FOR YOU

I WROTE THIS FOR YOU: JUST THE WORDS

I WROTE THIS FOR YOU AND ONLY YOU

25 LOVE POEMS FOR THE NSA

INTENTIONAL DISSONANCE

HOW TO BE HAPPY: NOT A SELF-HELP BOOK. SERIOUSLY.

I AM INCOMPLETE WITHOUT YOU: AN INTERACTIVE JOURNAL

300 THINGS I HOPE